TO SEE

POEMS BY MICHAEL McFEE

To See

Photographs by
Elizabeth Matheson

NORTH CAROLINA WESLEYAN COLLEGE PRESS

These photographs were part of an exhibition by Elizabeth Matheson at the North Carolina Museum of Art from February 24 through May 6, 1990. This sequence of poems based on those photographs was first read at the museum on Sunday, March 25, 1990. Four of these photographs and poems—*"Daytona Beach, Florida, 1981"*/"Psychoanalysis at Watson's Motel," *"Versailles, France, 1971"*/"What Matters," *"Beaufort, S.C., 1987"*/"Edgar Poe and the Air Conditioner," and *"Quebec, Canada, 1977"*/"There"—were published in the Autumn 1990 issue of *Preview*. Duke Hospital Cultural Services published *"Wilson, North Carolina, 1982"*/"The Photographer Across the Street" as part of its Duke North Courtyard Project in 1990. Thanks to all the people who made this collaboration possible.

PRINTED IN HONG KONG

LC 91-62756
ISBN 0-933598-34-3 (Trade)
ISBN 0-933598-35-1 (Limited, signed)

Supported in part by a grant from the North Carolina Arts Council with funds from the National Endowment for the Arts.

Published by North Carolina Wesleyan College Press, 3400 North Wesleyan Boulevard, Rocky Mount, North Carolina 27804

And if his conscience is clear, the writer's answer to those who in the fullness of a wisdom which looks for immediate profit, demand specifically to be edified, consoled, amused; who demand to be promptly improved, or encouraged, or frightened, or shocked, or charmed, must run thus:—My task which I am trying to achieve is, by the power of the written word, to make you hear, to make you feel—it is, before all, to make you *see*. That—and no more, and it is everything.

—Joseph Conrad, 1897

TO SEE

WHAT MATTERS

Not plot,
the revolutionary scheme being hatched
by the gardener, the courier, and the ticket-taker
as they flirt with the photographer.

Not character,
that agent with something under his trenchcoat
striding purposefully toward the fountain.

Not even setting,
the grand enlightened palace and grounds,
centuries of topiary pruned to a lethal point.

But timing,
seizing the scene at the perfect moment,
its details charged with utmost possibility

so that
something as apparently trivial as that window
open in the Sun King's flawless facade
can sing its dark secret across the garden.

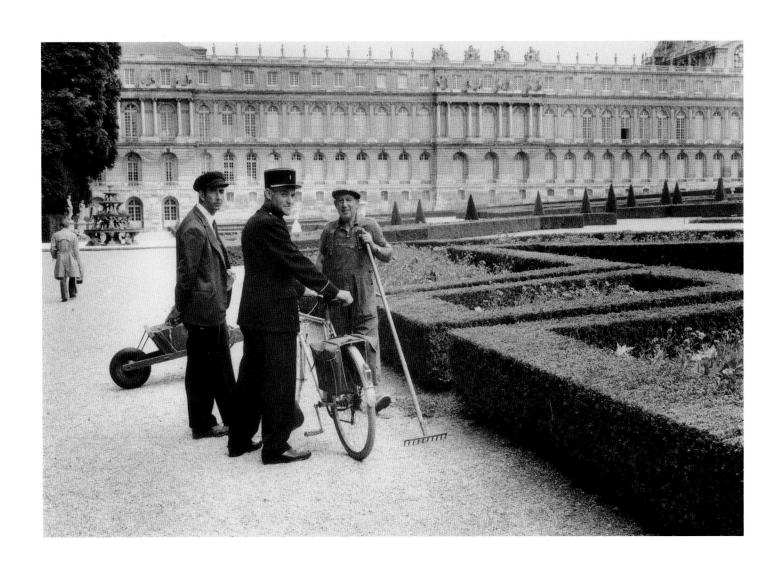

Versailles, France, 1971

ANTI-MANIFESTO

Don't expect to be shocked
by a train bursting around the curve,
a ship slipped into the channel.

It's tempting, but don't look
for tourists to puff gruffly into view,
or even a quaint local.

Instead, watch that beak
of water needling the distant cliffs,
the chainless black poles,

the clouds like clean smoke.
And memorize that fine line of light
lightly riding the rails.

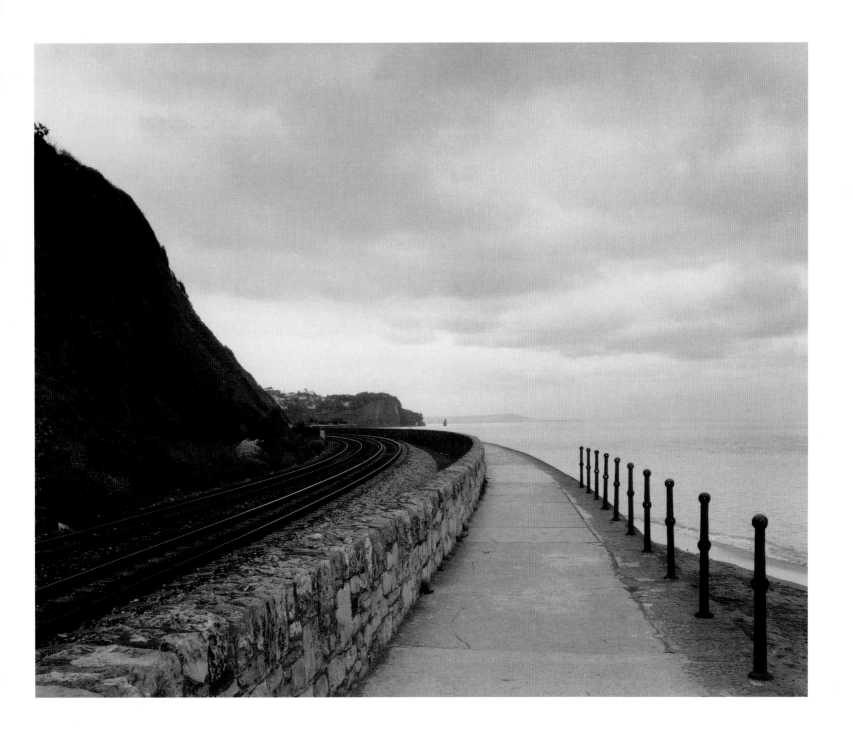

Dawlish, Devon, England, 1989

A WINDOWSEAT IN ABERYSTWYTH

You might sit here all day,
plump the pillow, crack the heavy window,
wait for some creature all consonants
to wander into frame,

but even if nothing came
it would still be perfect: the curve
of the retaining walls, the pasture's slope,
the thick breath of the bay

hiding the cattle, the ritual
circle of fence that saves an oak-trunk
from desecration. Even the practical latch,
in silhouette, is beautiful!

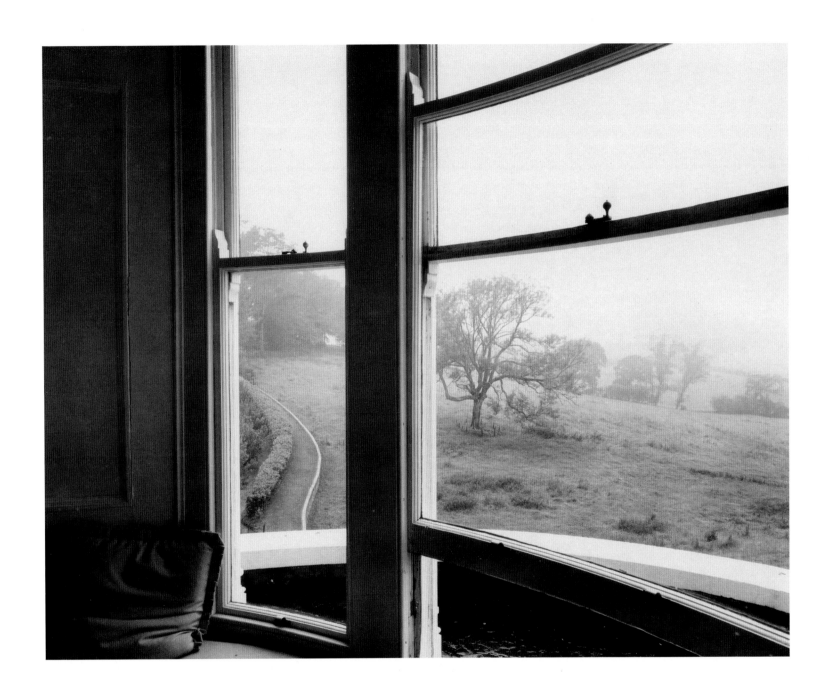

Aberystwyth, Wales, 1986

EDGAR POE AND THE AIR CONDITIONER

From his johnboat in the sound,
Poe regards the dilapidated mansion.

It is the death of a beautiful woman,
it is melancholy itself,
it is perfect.

He falls into a feverish swoon
and does not wake until his black prow
mires in rank sedges.

He wades ashore like a weary egret,
expecting peculiar stringed music,

but hears instead an alien hum
from the window above,
the coffer balanced on its ledge.

All night Poe paces, cool and dry,
composing a poem about Pandora's box.

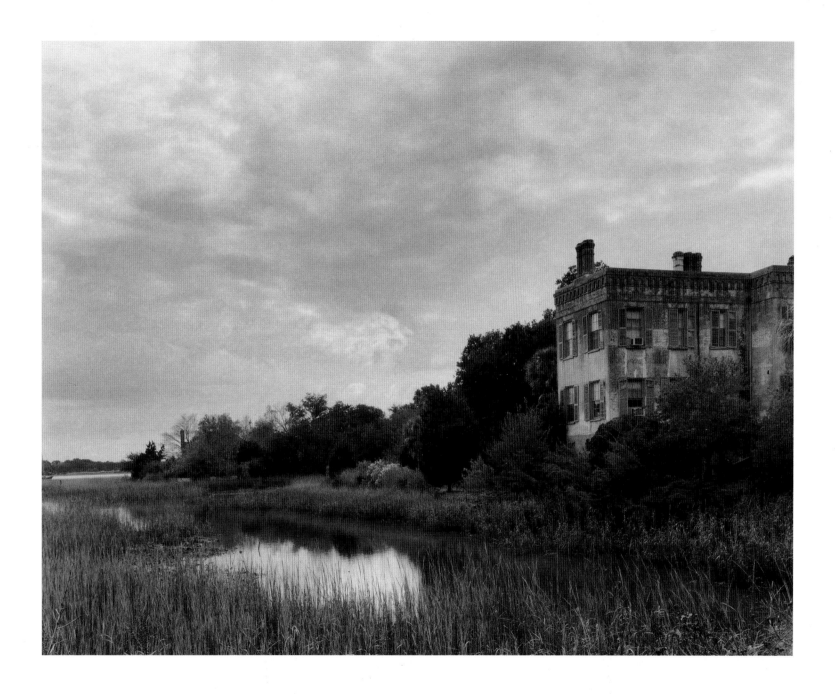

Beaufort, South Carolina, 1987

RENDEZVOUS

At midnight every Midsummer Night
Caedmon, the father of English poetry,
meets Dracula at this trim stand

for ice cream. They lean on the rail
licking their vanilla and chocolate
and listen to the North Sea lay siege
to the cliff, as it has for millennia.
Their napkins disappear into the sound

and then they vanish: Caedmon pausing
to read his stone song in the graveyard,
thirsty Dracula drifting into Whitby,

and then this stand, a seasonal temple,
an impeccable old Yorkshire citizen
gliding down the flagstones to the sea
whistling through its quincunx vent,
its cone a lifted torch in the night.

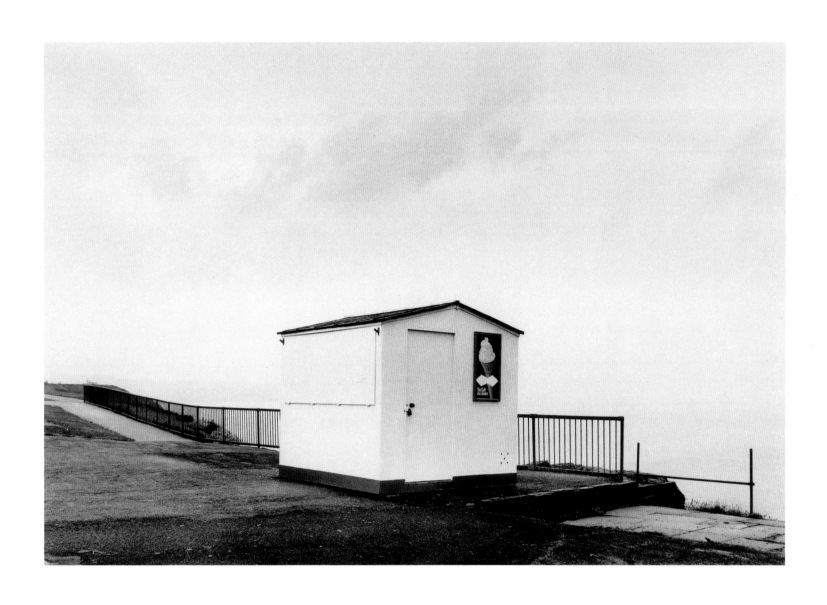

Whitby, Yorkshire, England, 1978

CASTLE DRACULA — NOW BETTER THAN EVER

The count is stranded in sunlight:

two huge crucifixes advance on him,
a one-way stake may turn on his heart,
his cedar coffin waits under the boardwalk,
the human beings haunting the arcade
have already been drained of their blood.

The count is now worse than ever:

he is half-vanished, he is aghast
at the white Continental idling for him
here in the bright New World where myth
is amusement, in a treeless Transylvania
known as Wildwood, New Jersey.

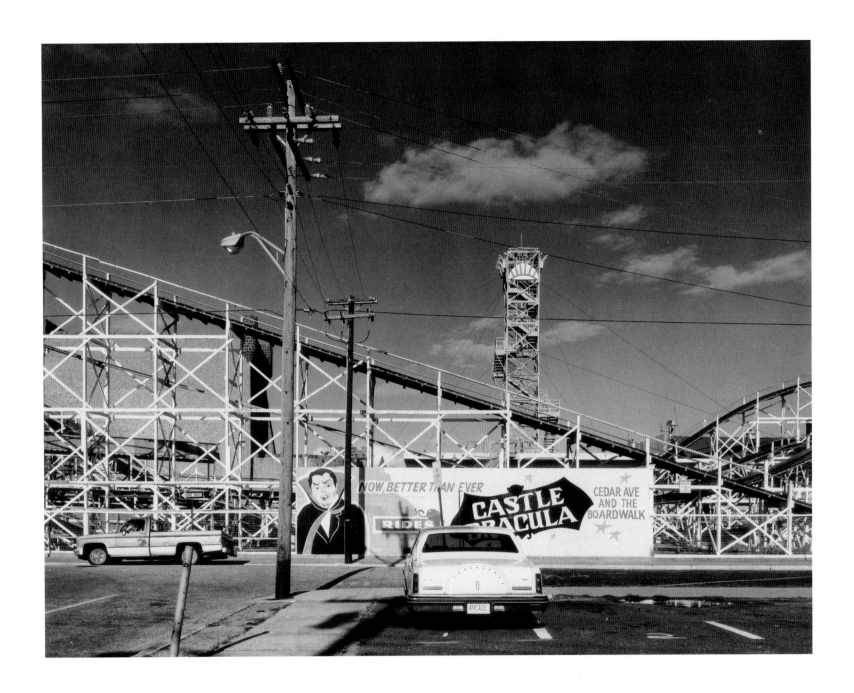

Wildwood, New Jersey, 1980

FILM NOIR

No wonder no one
waits in this garish corner of the resort,
this heavy-handed set for a nightmare:

wide black stairs for the villain's descent,
his gloved left hand
caressing the overwrought iron rail,

the french doors through which the heroine backs,
the bows in her hair and dress
echoing the monstrous valances overhead,

the two tiptoeing toward each other
across the marble chessboard of the floor,
its trapdoor squares . . .

But no. Nothing happens. The scene has been cut.
And so the wind sweeps in,
lifting the shears in an opaque flourish,

a gesture of erasure and relief,
the first step of a dance
that will leave this room nothing but light.

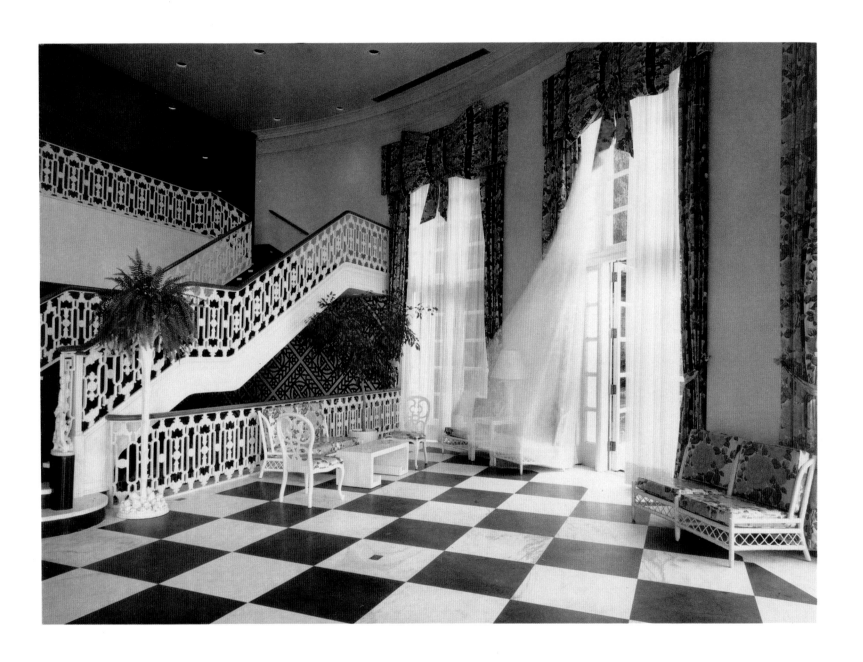

White Sulfur Springs, West Virginia, 1981

TRUTH

You sat on the steps in the cold sun
for what seemed like hours, but your date
never came and the theatre never opened
and suddenly you realized: this is just
a dream, a montage of symbols, an outtake
from the psyche's epic movie, *Wahrheit*.

What to make of it all, that scrapbook
jumble of faces locked in coming attractions,
the hexagonal ticket booth abandoned
except for reflected trees leaning forward
to whisper through the slotted mouthpiece,
sunlight off metal brighter than neon,

dim stars shooting upward, and above all
those letters THEAT hovering like a threat?

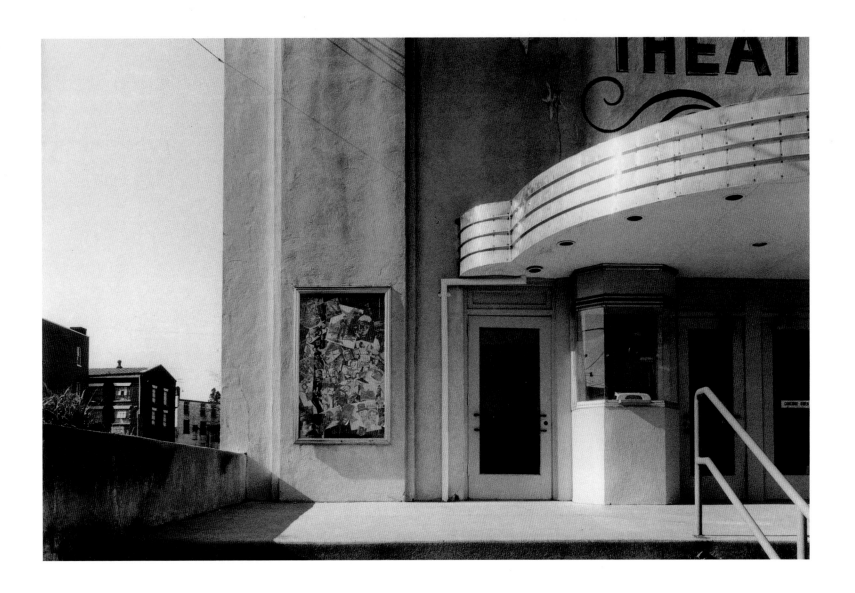

Chatham, Virginia, 1976

SCENE FROM *THE END OF THE WORLD*

Great Yarmouth is doomed!

A few dozen survivors
have fled to the municipal beach
to escape the lethal fog
that is erasing their city
in the background, a mere mirage
about to evaporate.

They improvise defenses
against the feverish North Sea
that will never stop rising,
its crude jellyfish:

one partial family heaves
trinket seashells at the breakers,
a father and his motherless son
build their final castle,
another couple tries to stop
the ruthless tide with their feet,

but everybody else surrenders,
retreating before the water levels
everything, the end of the world
blank as its beginning.

But one who never moves
is the old man in the cardigan,
his back to the camera, head down,
hands clenched in pockets,

whose long dream this is.

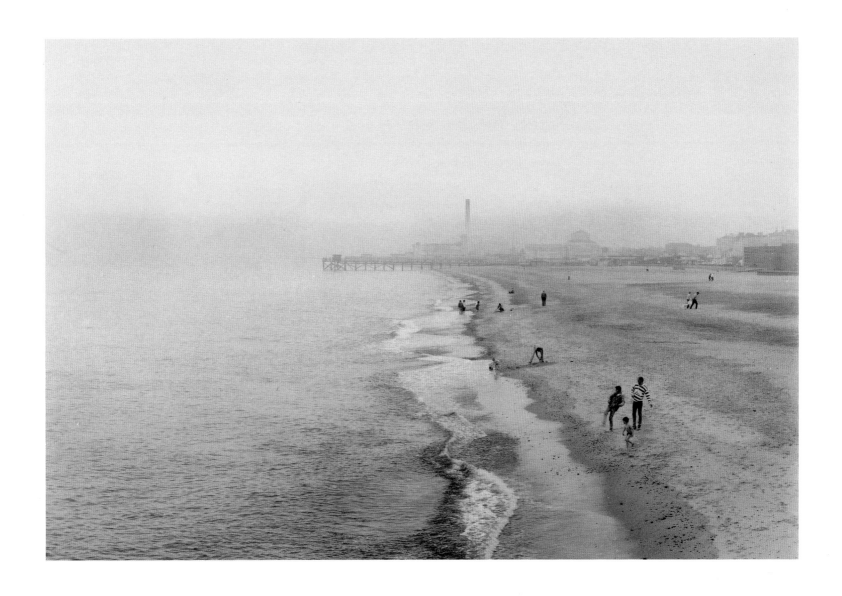

Great Yarmouth, Norfolk, England, 1988

AT THE EDGE OF THE KNOWN WORLD

At low tide, this pagan ocean
seems convertible, and so we wade
well into it, cheerful missionaries
playing games in waist-high water
to attract the curious natives,
bravely strolling its apron of surf
with a child whose passion for water
is a natural argument for baptism,
fashioning the beach's wet cement
into channels, sea walls, churches.

But when the tide turns, we retreat
from the fear still rising within us,
the power of darkness in our blood
and in the ocean that takes the beach,
the shorewalk with its slimy masonry,
the rock on which the town is built,

and we watch the unholy water threaten
to storm the wall with its rumors
of mermaids, lost Atlantis, a world
so new that light itself is a miracle.

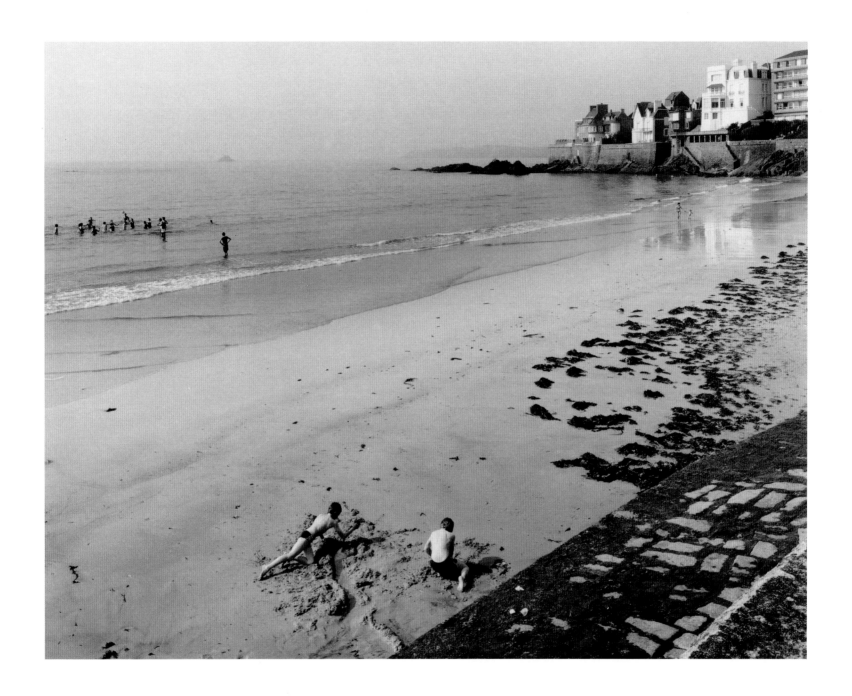

Saint-Malo, France, 1983

ORTHODOXY

It's 1:10 in Abbotsbury, the vicar has dined,
and everything is gospel in the garden:
the transfigured laundry on the line,
the undershirts, the towels, the sheer curtains—
all follow the doctrine of the hardy Dorset wind.

At least if the chapel's vane can be trusted,
hasn't stuck to the west-northwest again.
And if the clock's uplifted hands aren't rusted.
And if we can believe the tipsy witness
of that cross leaning in at the last instant
like a pious aside, its stone a Celtic compass
warped by the wind's magnetic argument.

O cabbages, o inscrutable sky and wall,
o spotless little socks and local squall!

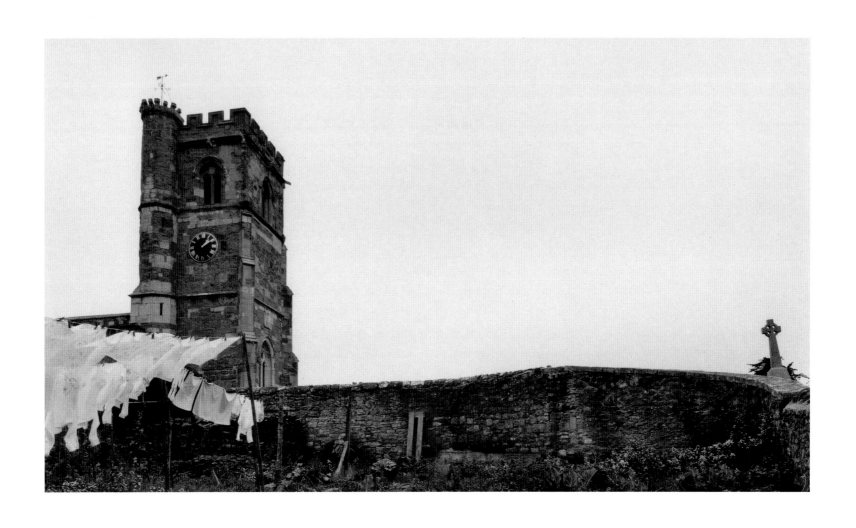

Abbotsbury, Dorset, England, 1989

FELIX CULPA

It's the steady pressure of paradise
we can't stand, afternoon clouds
level as a Renaissance chapel ceiling
over the blinding horizontal of a wall,
stools with flawless shadows paired,

the pool, a perfect whole from any angle.

And so we praise God for any trouble—
one stool supplanted by a bag of tricks,
deck chairs sneaking into the picture
like escaped convicts, that odd wide shadow
about to poison these untroubled waters.

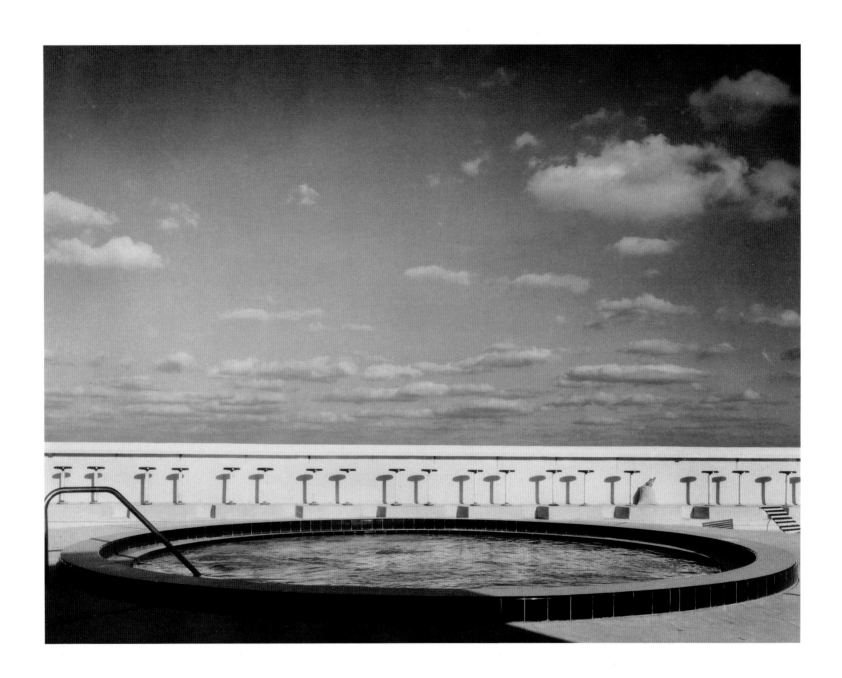

Miami, Florida, 1985

WACHET AUF

Such tidy sleep!—
a brief nap with a briefcase
for pillow, or a shopping bag,
or a jacket, folded and fluffed just so.

And yet so intimate,
the sun their only cover,
their bodies turned as if to lovers—
a bare foot ready to hook
a bare foot, an open parenthesis of knee
feeling for closure, a leg
languorously cocked in afterglow.

And all so oblivious
to steadily encroaching doom:
the warning flares of ornamental grass,
the trees whose voracious shade
is creeping downslope,
the faint sinuous approach of something
coiling to strike . . .

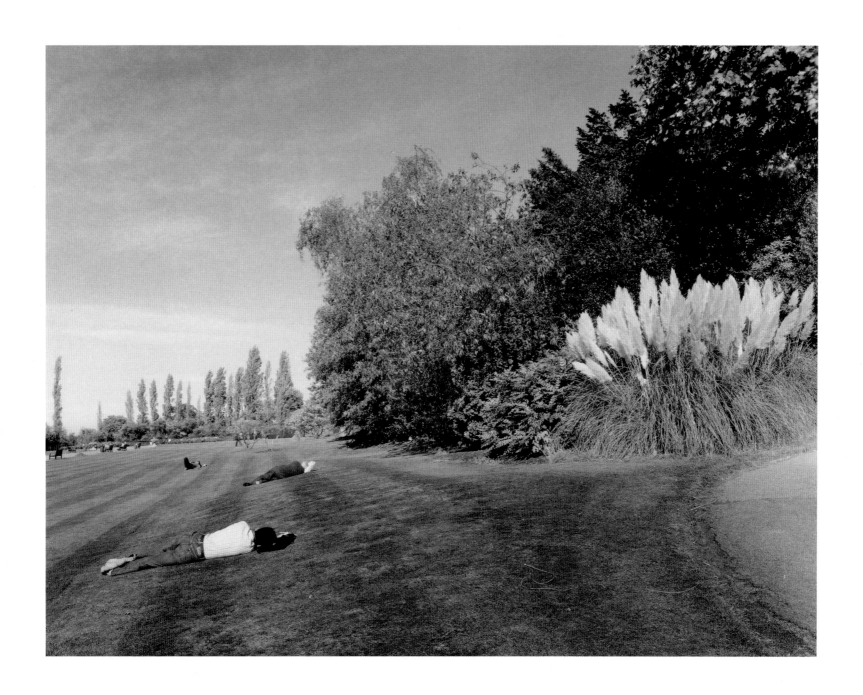

Regent's Park, London, 1989

ROMANTICISM

The lawn is fresh-pressed, the garden tweezed,
the prudent hedge pruned at head level,

but the statue is daydreaming again,
he's tired of this whole neoclassical scene,

he turns his back on it and his thoughts rise up
like restless exclamations of lombardy poplar!

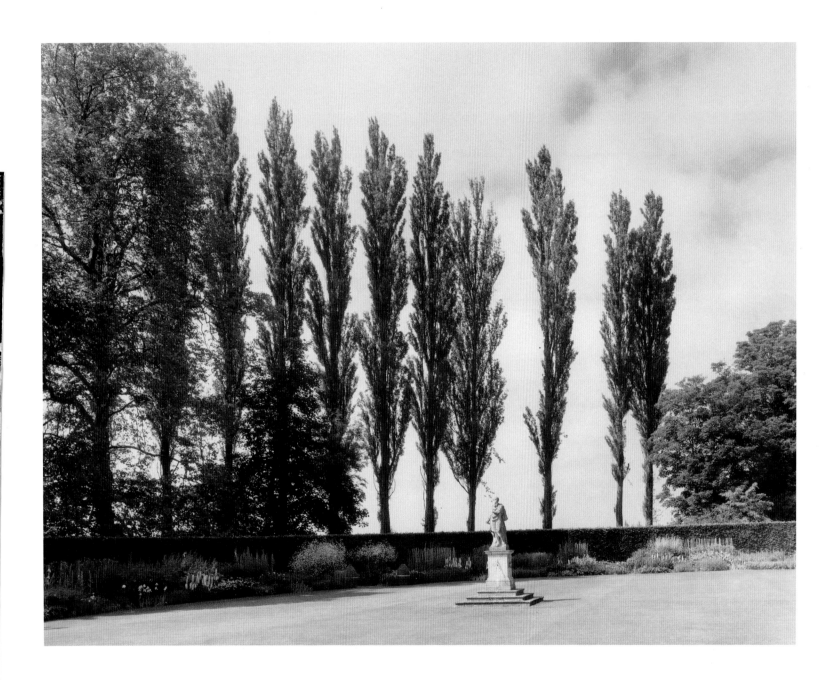

Cambridgeshire, England, 1988

THE PHOTOGRAPHER ACROSS THE STREET

Father and son guard their toy yard
against the photographer across the street,
unaware that, behind them,

the angry houses blink their eyes
and neighborhood trees make threatening gestures
at the photographer across the street,
unaware that, behind them,

a water tower looms like the Bomb,
Jacob's ladder twining its mushroom stem,
its metal cloud gleaming
for the photographer across the street,
unaware that, behind it,

a thunderhead boils till it fills the sky,
God's troubled mind
rehearsing all the graven images,
the thievery, the false witness, the transgressions
of the photographer across the street,
unaware that, besides Him,

there is only the photographer across the street
dividing the light from the darkness.

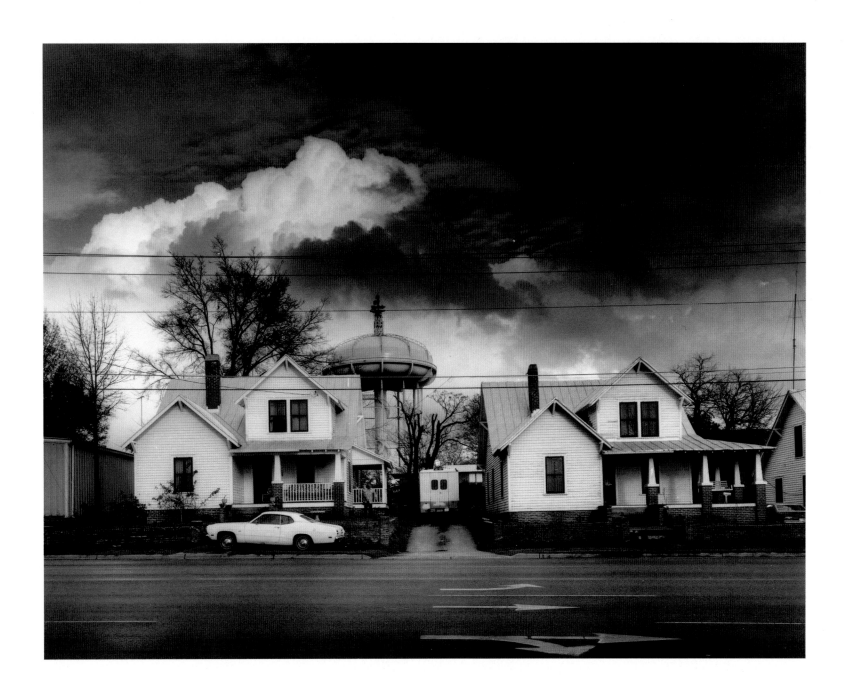

Wilson, North Carolina, 1982

THE TREASON OF IMAGES

Descartes has bored Magritte to sleep,
he is dreaming a peculiar picture:

a wide beach stippled with footprints
but not a soul in sight, only these

little white houses on wagon wheels
yearning to bathe in the cold North Sea.

They face the water like hungry gulls.
They wait for the ancient caretaker

who comes at dusk to open their doors
and fill them with all the scenery

they can hold—canvas windbreaks, beach
and ideal sea, comic clouds and sky,

the black staircase. And then the man
holds his bowler to his face like a camera

and, with a click, makes each house vanish
into the hat!—Magritte wakes to Descartes

still reasoning: *Cogito, ergo sum.* Yawning,
Magritte mutters: *Ceci n'est pas une pipe.*

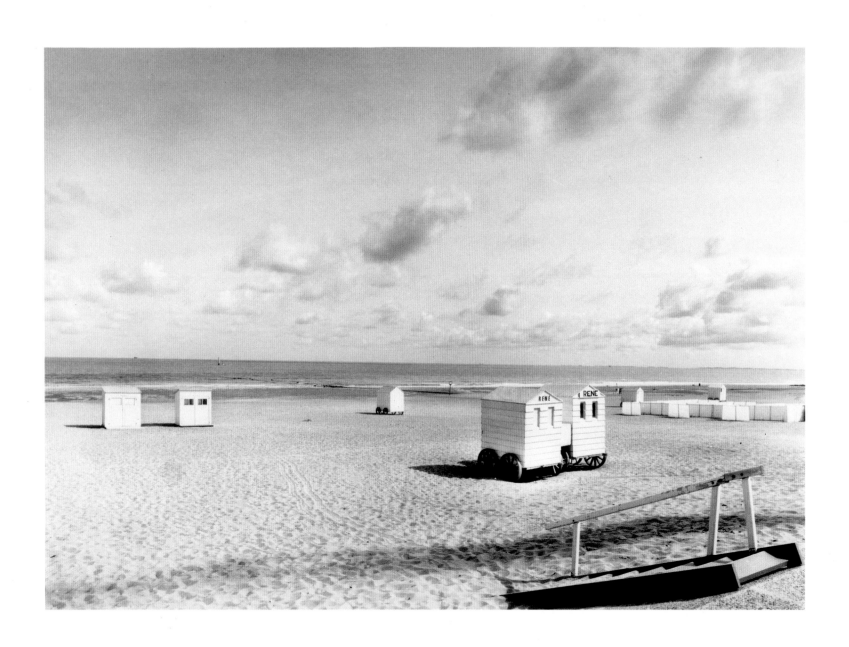

Knokke-Heist, Belgium, 1983

MAPLEWOOD CEMETERY

The dead are grateful
for any attention we give them:

the pressure of a careless foot,
a half-muffled laugh,

lovers or drunks
warming the scar of their grave,

the caress of a bent human shadow
on the granite

resurrected to bear
their name. The dead can even love

the camera whose click means *light*,
its immortal coil

of memorial plots—
an angel adoring the man in black.

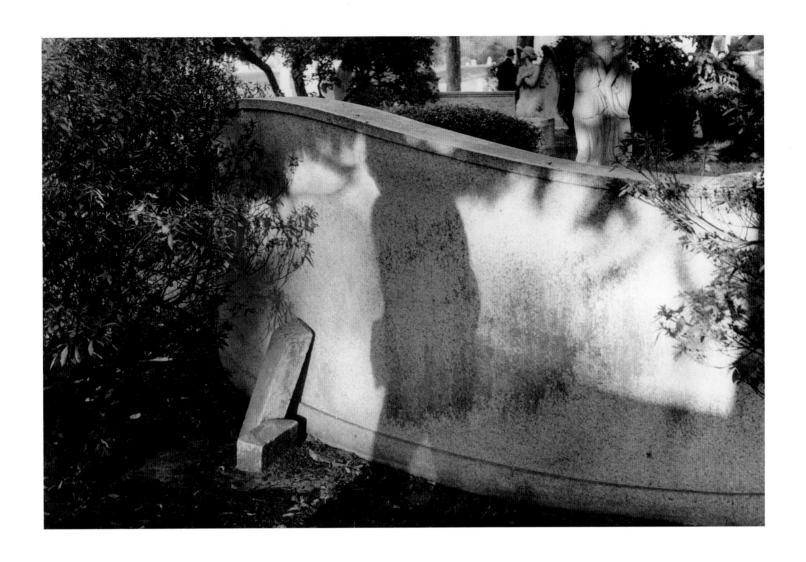

Durham, North Carolina, 1975

NORMANDY

The plastic chairs chat on the patio,
they have drunk all the house wine
and the tables have been cleared

but still the chairs keep talking
in the empty café, under a feeble flag,
they can't quite see over the rail
where tiny tourists try to pin the hem

of the English Channel, imagining
what strange invasion might have left
this colossal dumpster-like craft
behind on such a lovely stretch of beach,

what strategy might have once required
a false harbor in such calm water
under such a quiet soft harmless sky.

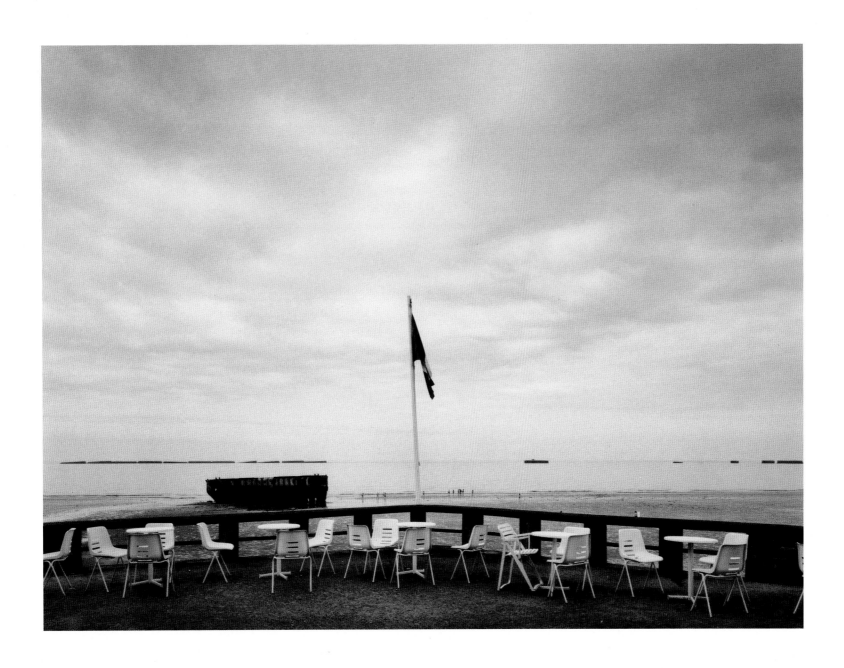

Arrowmanches, France, 1983

CHANTEY: BY THE SEA

Three bicycles by the Sea,
loitering

at the end of this empty deck
by the Sea,

by the rail by the Sea
where three surfboards also wait,

their ventral fins
plowing the breeze by the Sea,

nobody left to strike poses
by the Sea,

everybody hypnotized by the Sea
and its pocketwatch sun

into dancing
by the Sea in the cool pavilion

with the ghosts of presidents
becalmed by the Sea

while their bikes and boards idle
outside, by the Sea.

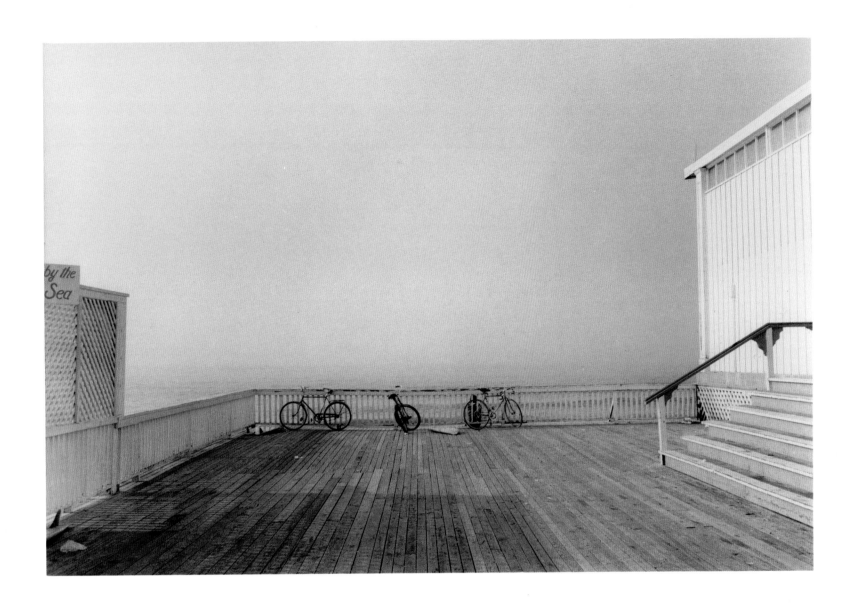

Cape May, New Jersey, 1979

ARCADIA DRIVE-IN

Little loudspeakers bloom in perfect rows
across this field, trailing their vines
down bright white stalks.

Every weekend, the lovers come
for a transfusion of passion and static,
a couple of cars to each pole.

And the drivers on 421 slow down,
hoping for a glimpse of some heavenly body
in the screen's big window.

But for now all that's showing
is a faint profile of some boundary trees,
their shadows haunting the screen.

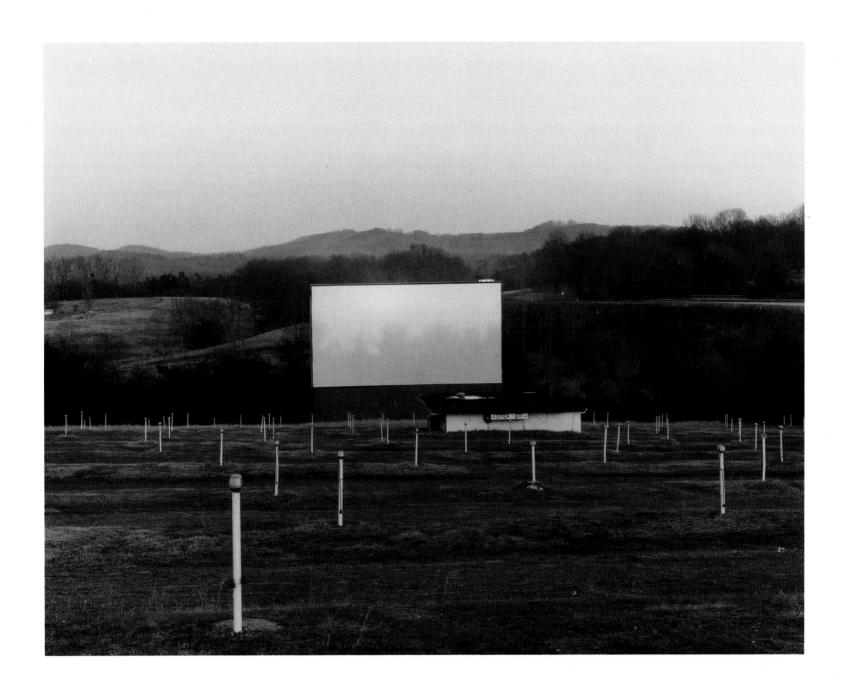

North Wilkesboro, North Carolina, 1982

GRAVITY AND GRACE

You could scout the mansion's portico
for signs of fading care,
its Doric order warped and crazed
by expensive salt air.

You could savor the easy irony
of sprinklers overhead.
You could knock the hollow pillars
of privilege, long dead.

Or you could stroll across the porch
during a wee hours dance,
lean back against a column, smoke,
enjoy the romance

of such grandeur, however worn,
and offer your hot face
to the touch of the millionaire ocean,
that graceful scapegrace.

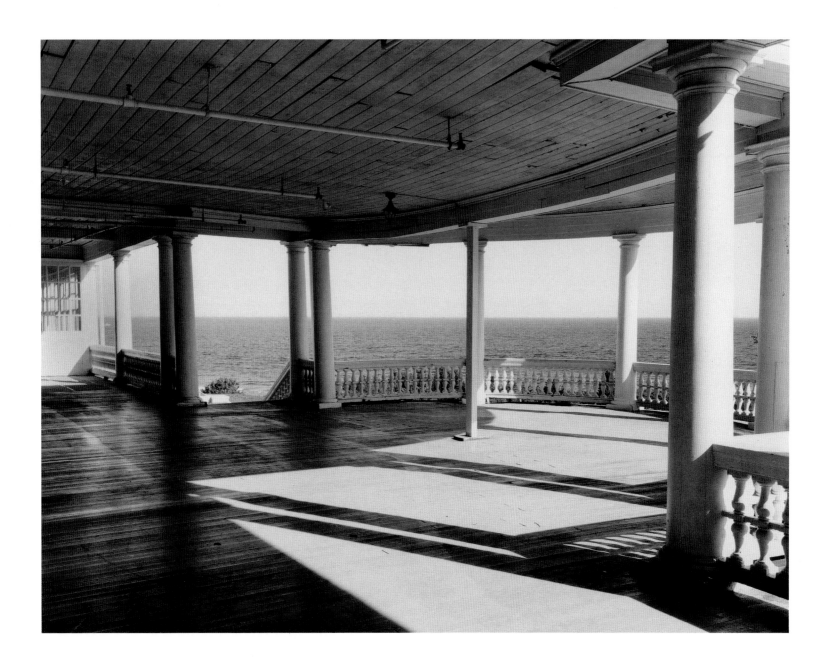

Watch Hill, Rhode Island, 1989

RESORT

In Brighton, even the carpark
is a tribute to leisure and empire,
its monumental arcade blessed
by keystone gods, its lamp highlighted
with chorus lines of naked bulbs.

Neptune croons "God Save the Queen"
to vacationers beginning their escape
to promenade, pavilion, royal pier,

a world where scale and embellishment
are still possible, a gaudy heaven:
true holiday, the gaudier the holier.

But every resort implies a return.
All night, the curious terrace hotel
watches people descend to dark cars
under the strung-out golden jubilee
of suns that may burn out but never set.

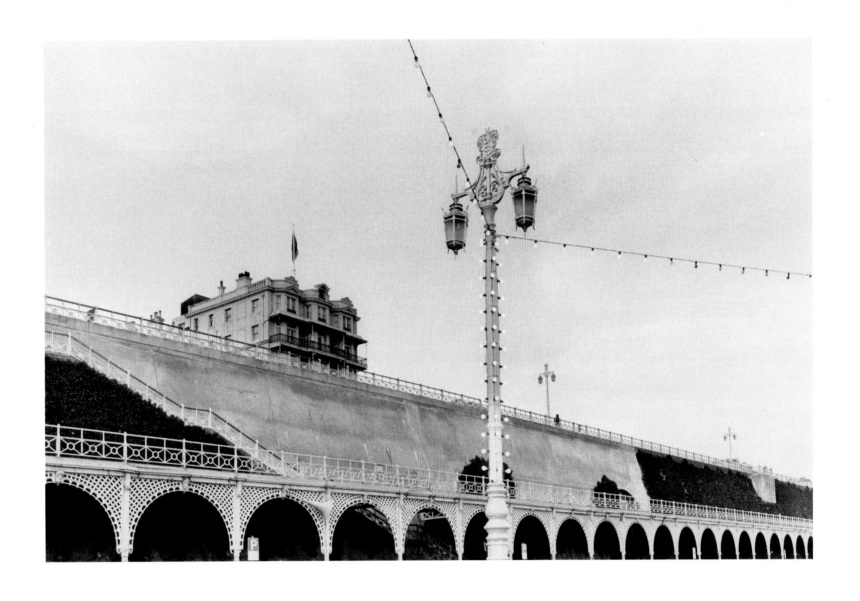

Brighton, England, 1978

PSYCHOANALYSIS AT WATSON'S MOTEL

The ego sunbathes by the motel pool
while the superego insists NO VISITORS—
NO EXCEPTIONS, building its guilty wall
with wrought-iron spikes for privacy.

But it can't keep out the curious id—
the palm tree's flamboyant bayonets,
those gut-wrenching carnival rides
pausing to peer over the whitewashed blocks,
the sun, that irrepressible hedonist.

And it can't keep the dolphin from smiling
as it penetrates the life preserver again
by the pool where the ego suns itself.

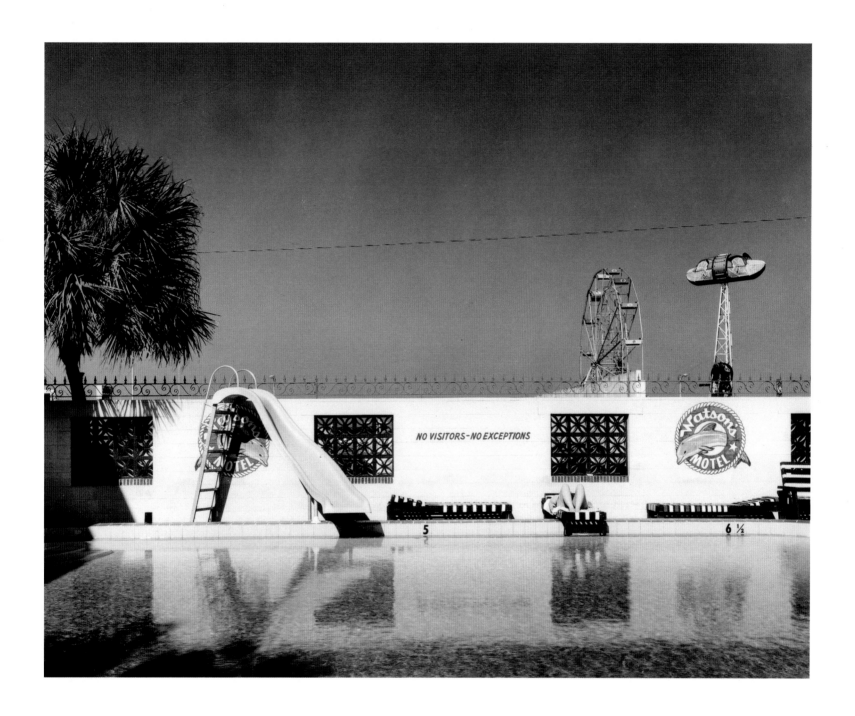

Daytona Beach, Florida, 1981

A BRIEF CORNER OF ORDER

Against the unimaginable wilderness,
against the river, against the Chesapeake,
against the confederacy of Powhatan,

against the desperate colonists,
against the Redcoats and Cornwallis' surrender,
against the Yankees' peninsular campaign,

against the dead troops surrounding the town,
against the omnivorous chaos of kudzu,
against the invasion of the merely curious—

these sections of weathered white fence
with some chicken wire tacked at the bottom
to keep something out, or in, or both.

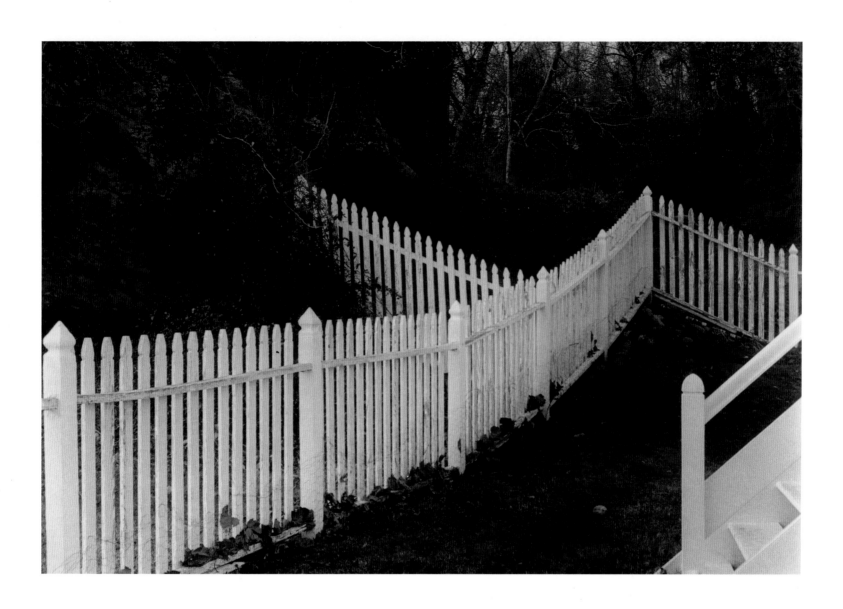

Yorktown, Virginia, 1974

STAY

Like a blur of seals at the zoo
two girls play in the seaside pool,

its weathered solid geometry
a temporary sanity, a momentary

stay against the black bluff
and the Atlantic gathering itself

to erase the perfectly unnatural
superimposition of a guardrail

and a terraced concrete beach.
But for now it can't quite stretch

to the pool, so the slick pair bark,
diving for nothing in the freezing dark.

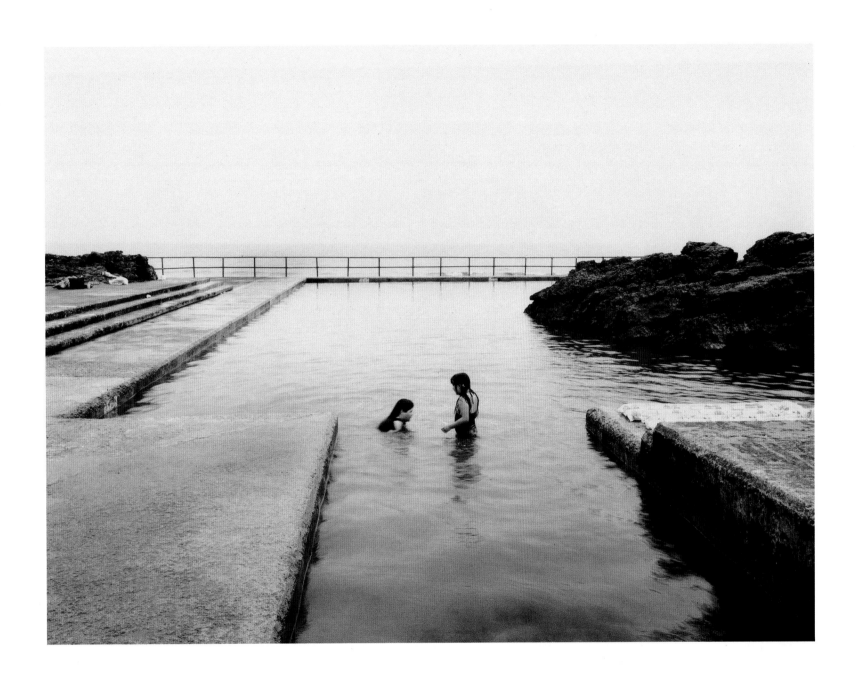

Porthcawl, Wales, 1986

LINES

The world's obsessed
with lineation, breaking waves

mirroring sky, ribbed sand
echoing both,

that broad sweep
of stairs extending the pattern

around the point, up the cliff
to the Grand Ballroom

where couples trace
graceful angles under a heaven

crowded with mythological lineage,
connect-the-dot stars.

Strata, furrows, ripples:
the world's an index of first lines

in a foreign language we'll never
master, and sometimes

we discover ourselves
stranded between them, frowning

at the relentless perspective,
our lost lineaments.

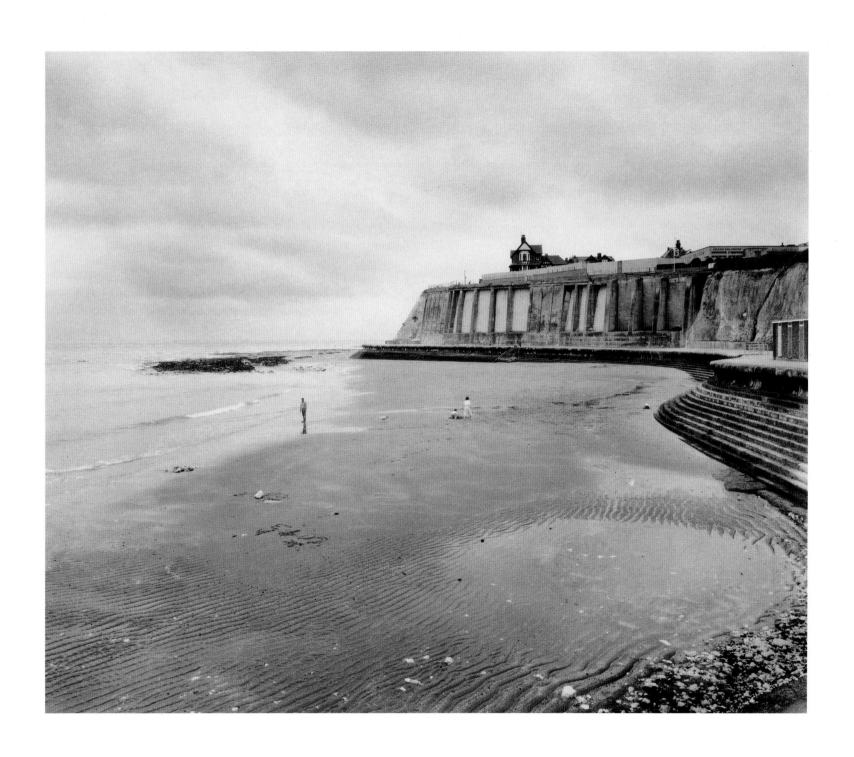

Broadstairs, Kent, England, 1988

RETIREE ON A STREET CORNER

There's a little metal panel at my feet,
set in a special delta of concrete,
but I simply can't read it.

And my eyes are tired, they can't decipher
the words on that dark historical marker
by the flagpole over there.

And my neck won't bend so I can't quite see
what flags are flying or if these trees
shooting the tropical breeze

are palms, as usual. And why are my feet heading
toward that Italianate marble building
whose name is partly hidden

behind a trunk? Does it say FEDERAL? GENERAL?
MINERAL? LIBERAL? or maybe even FUNERAL,
the word I came here to stall?

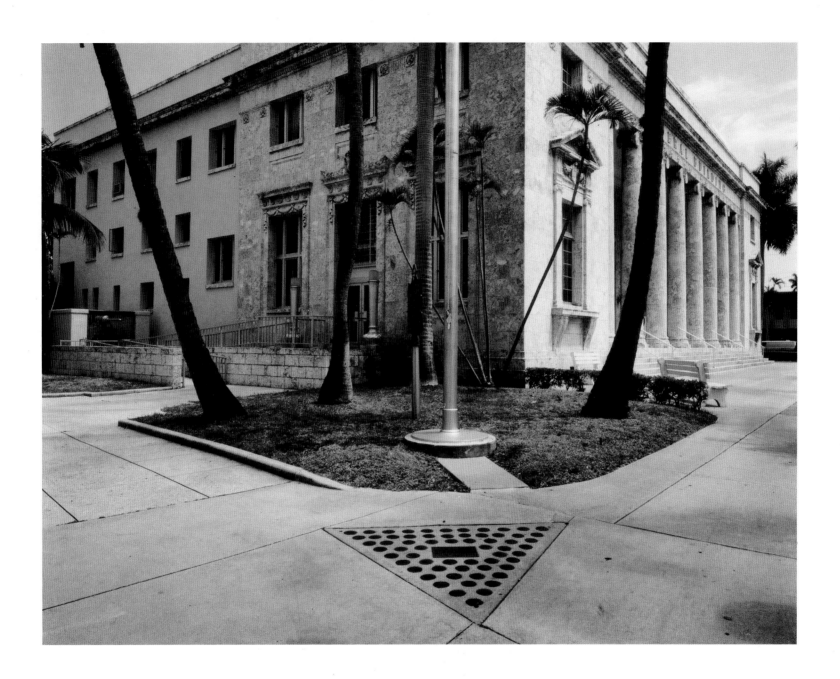

Fort Myers, Florida, 1981

THE WRONG SIDE OF THE WALL

Mr. Capaldi has parked his ice cream trailer
on the wrong side of the wall, over there

there's traffic and a stop light shining,
there's a memorial obelisk and busy town square,

people might look out their windows and think
how perfect a strawberry ice would be,

workers could shout down from their scaffolding
for pretty girls to bring them some sweets,

but over here there's nothing but empty spaces
and minor litter blown in from somewhere else

and a tree filling the sky like black lightning
and Mr. Capaldi's shuttered ice cream trailer.

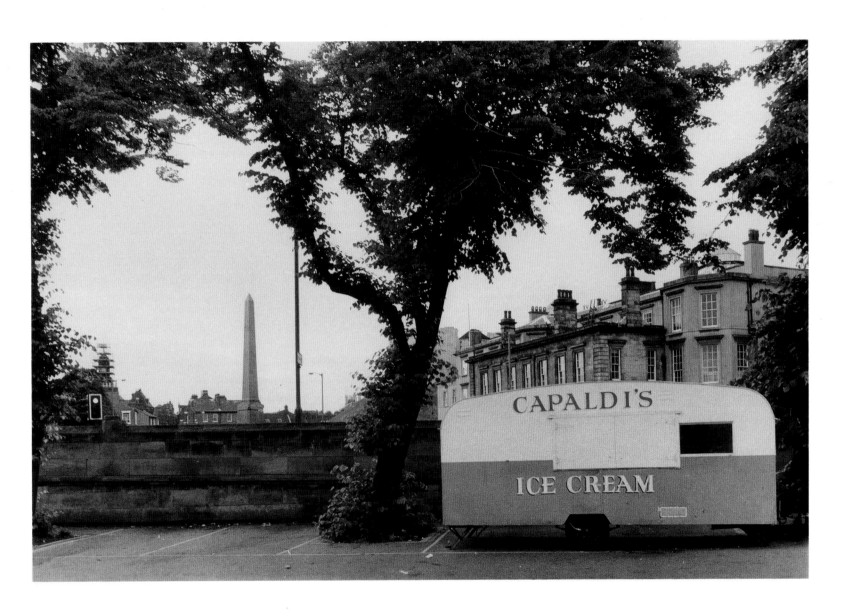

York, England, 1978

STRUCTURALISM

Here on the backside of the avenue
light is still light, shadow shadow,

the ground-floor words REFUSE AREA!
KEEP AWAY NO PASE signify no less
than the penthouse SANDS or ST MORITZ.

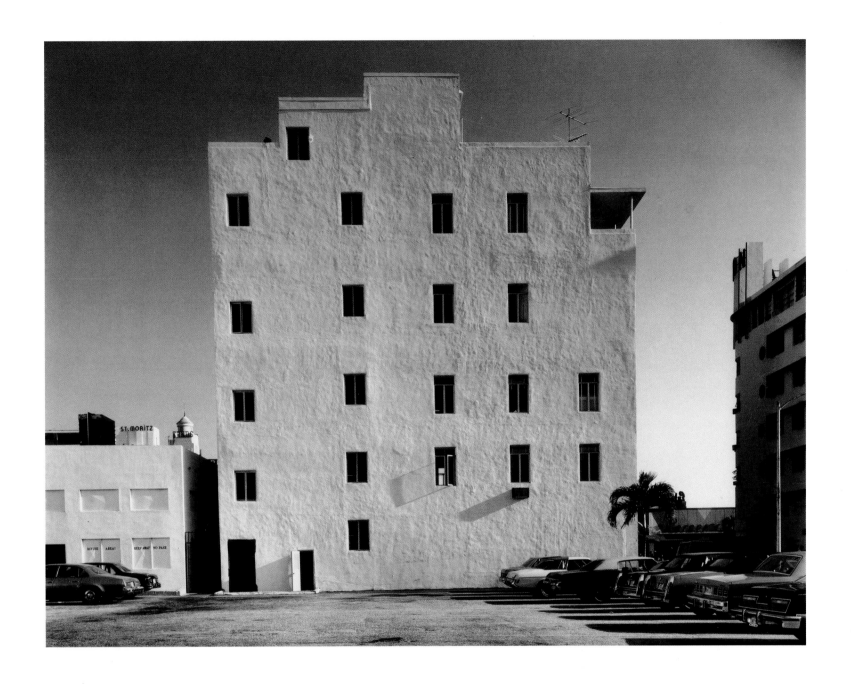

Miami, Florida, 1981

TO SEE

Alone in the waterfront bus stop
you might strain to see distant ferries
basting England to the continent.

You might wish you were on your way
to Zeebrugge or Calais,
but, squinting, you would miss
all this familiar perfection at hand:

the superb draughtsmanship
of flowerbed and fences, the Strait
supernaturally calm,
that sudden bright annunciation of clouds.

You would fail to see
how this transparent temple you wait in—
its barberpole fluting, those fancy capitals,
the black trapezoid of its roof—
is part of a larger pattern.

And you would fail to see
how you spoil and fulfill that pattern.

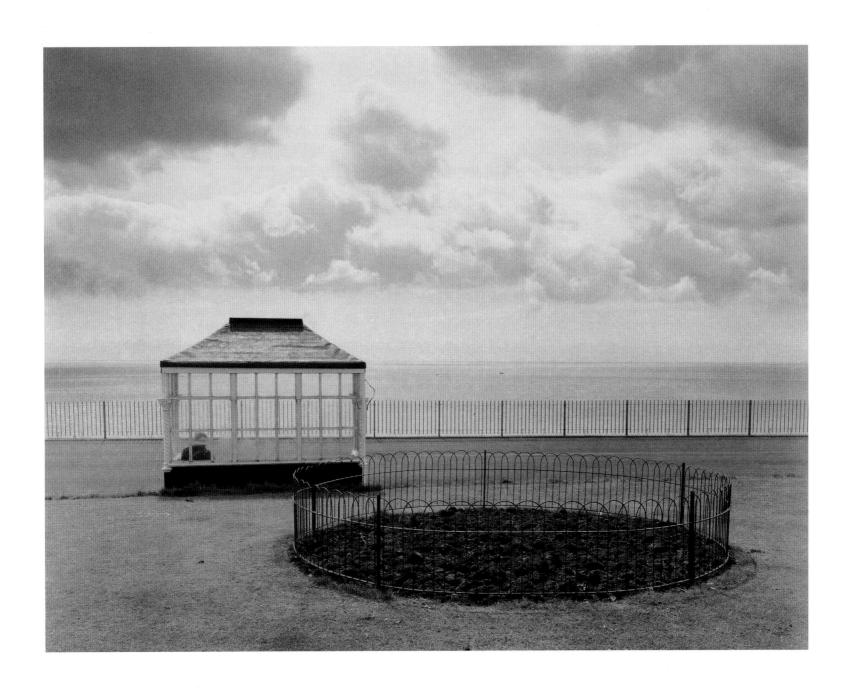

Deal, Kent, England, 1988

NOTICE

Not the swans, their picturesque poses,
the ludicrous metaphors they invite,

but the way that dark spit of land
buries its delicate neck in the water.

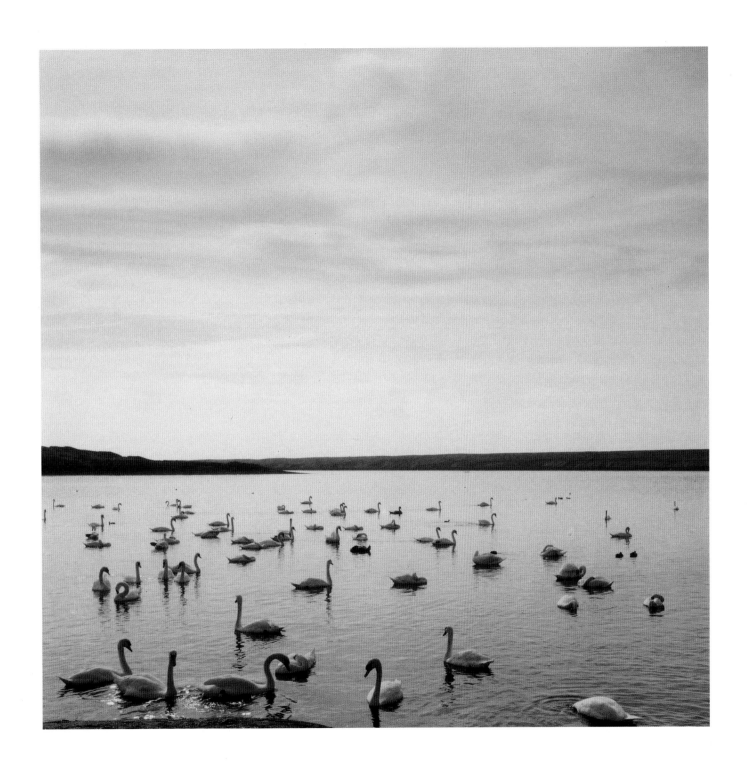

Abbotsbury, Dorset, England, 1989

AESTHETICS

This turnaround at field's edge
is *verse*, the turning
of the plow-line, enjambment
of furrow to furrow.

And the field itself
is *culture*, soil tilled in patterns
and with purpose, earth
made to say beans instead of grass.

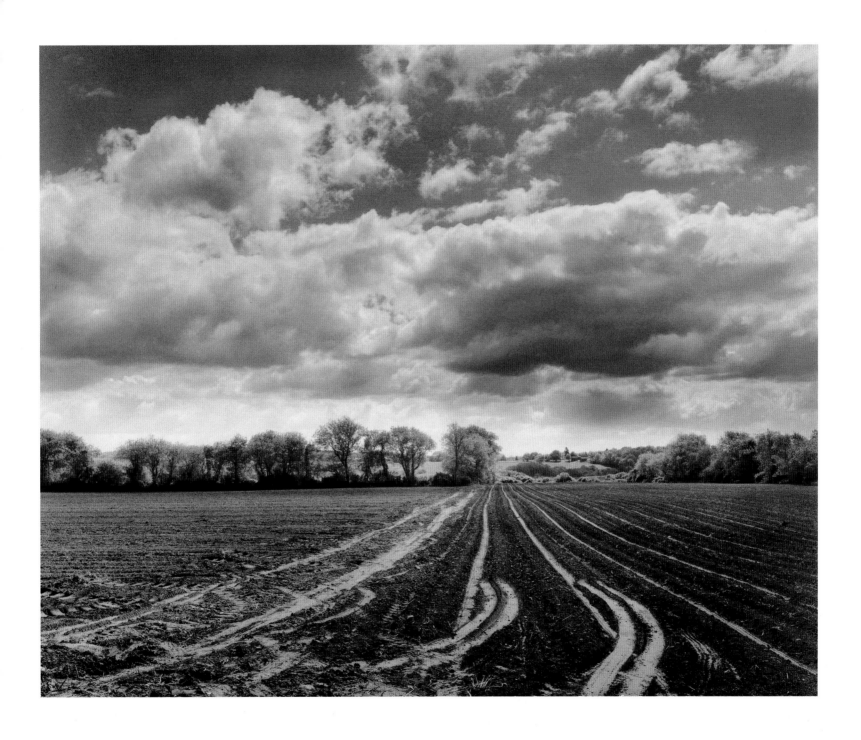

Near Sakonnet, Rhode Island, 1989

THERE

Just past the lamppost
at the crest of this hill
our bus will enter
an independent province
where the language is light

No customs no passport
no roundtrip ticket required
nothing to declare
except lasting allegiance
to the government of the sky

There the only thing we need
is an eye always open
a sense of humor
a ready hand
patience

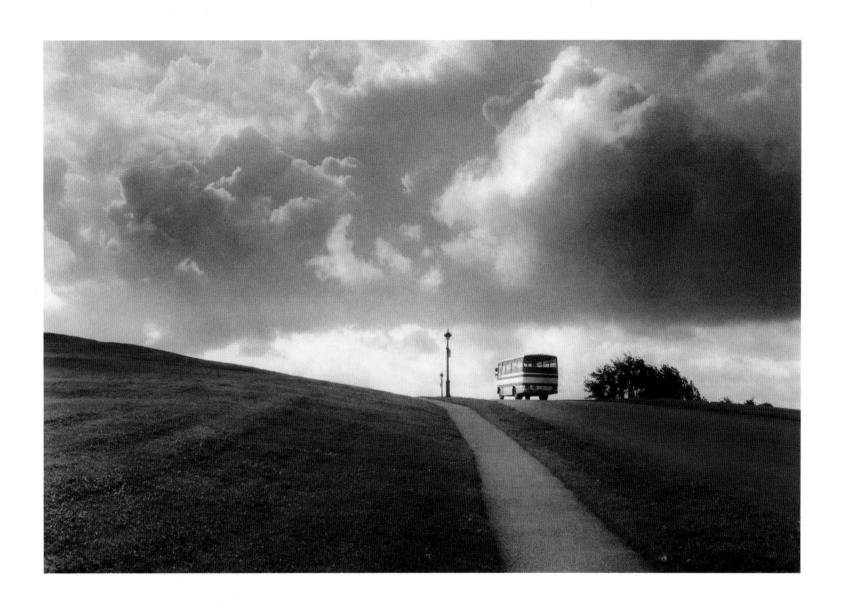

Quebec, Canada, 1977

ABOUT THE PHOTOGRAPHER

ELIZABETH MATHESON is a native and resident of Hillsborough. Her photographs have been widely exhibited, including the one-woman show at the North Carolina Museum of Art on which this book is based. Her work was also included in the "Nine from North Carolina" show at the National Museum for Women in the Arts in Washington, D.C., in 1989. She has been awarded an NEA/SECCA Southeastern Artists Fellowship and a North Carolina Arts Council Artist Fellowship. Her books include *Edenton: A Portrait in Words and Pictures*, and two forthcoming collections: a volume of photographs of England and Wales, to be published by the Jargon Society, and a photographic portrait of Hillsborough.

ABOUT THE AUTHOR

MICHAEL MCFEE is a native of Asheville and resident of Durham. He is the author of three books of poems, *Sad Girl Sitting on a Running Board* (1991), *Vanishing Acts* (1989), and *Plain Air* (1983). He has been awarded fellowships in poetry writing from the National Endowment for the Arts, the Ingram Merrill Foundation of New York, and the North Carolina Arts Council. He has served as visiting poet at a number of universities, including Cornell, Lawrence, UNC-Greensboro, and UNC-Chapel Hill. For the last decade, he has also served as book editor of *Spectator* magazine in Raleigh and as book reviewer for WUNC-FM in Chapel Hill.

This book has been printed in an edition
of one thousand copies of which forty numbered
copies are signed by the author and photographer with
a signed photograph from the book printed by
the photographer laid in. This book has
been set in Zapf Book Light by
Graphic Composition, Inc.

Design by
Jonathan Greene.